THE POCKET LIBRARY OF GREAT ART

Plate 1. SELF-PORTRAIT. *1897. Oil. Collection Durand-Ruel, Paris*

PIERRE AUGUSTE

RENOIR

(1841–1919)

text by

MILTON S. FOX

Editor, The Pocket Library of Great Art

published by HARRY N. ABRAMS, INC., *in association*
with POCKET BOOKS, INC., *New York*

On the cover
GIRL WIPING HER FEET *(see color plate 22)*

MILTON S. FOX, Editor

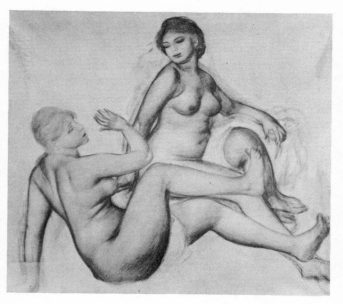

Plate 2. STUDY: THE BATHERS. *1884–85. Collection Desjardin, Paris*

Renoir

Renoir's art is that of a man on good terms with life. His inspiration had its source in a sensuous delight in the world, and from his enchantment came a flow of paintings unrivaled in their lyricism. His art is never burdened with ideas or marked with conflict. As all true artists must, he transformed what he saw;

but he saw with the eyes of a lover, and every element of his art affirmed his vision.

He was an amiable and uncomplicated man, free of disturbing tensions like those that give a sense of urgency, of painting as a refuge or comfort, to the works of some of his great contemporaries—Van Gogh, for example, or Degas, or Toulouse-Lautrec. He painted with such relish that his pleasure in his craft and in his subjects is at once communicated to us, and we are moved to say that no other artist has painted so freely, so spontaneously, and with so much joy. As a beginner, he was rebuked by Gleyre, a professor at the Ecole des Beaux-Arts, with whom he had his only formal training in 1862 and 1863: "No doubt it's to amuse yourself that you are dabbling in paint?" And Renoir answered: "Why, certainly, and if it didn't amuse me to paint, I beg you to believe that I wouldn't do it."

There probably was no impudence in Renoir's answer: it must have struck him as strange that one might paint for any other reason. Indeed, as an old man he said: "I've had fun putting colors on canvas all my life"; and the two statements, like a pair of brackets, enclose a career that is so rare in balance and gratification that it does one good to contemplate it.

Renoir's art differs from that of other Impressionists: it is not simply a reflection of the pleasant aspects of life. We see it rather as the triumph of an ideal of happiness and beauty, and a victory over distress. It is remarkable that in the immense body of Renoir's

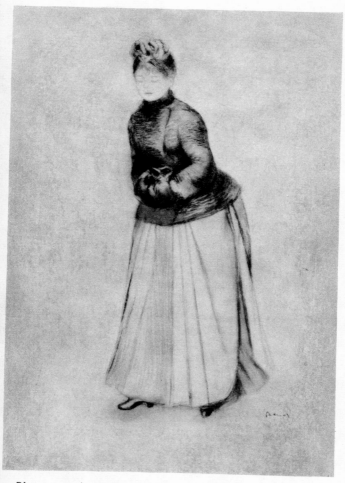

Plate 3. WOMAN WITH A MUFF. *About 1883. Sanguine*
The Metropolitan Museum of Art, New York

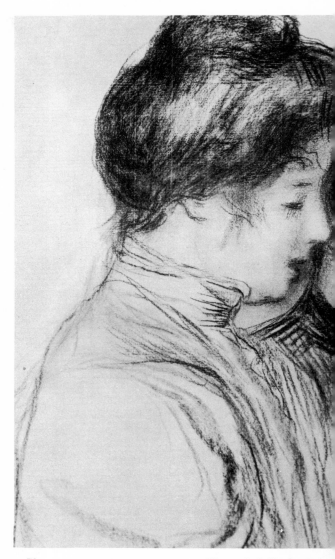

Plate 4. THE MISSES LEROLLE. *1890. Charcoal. Collection John*

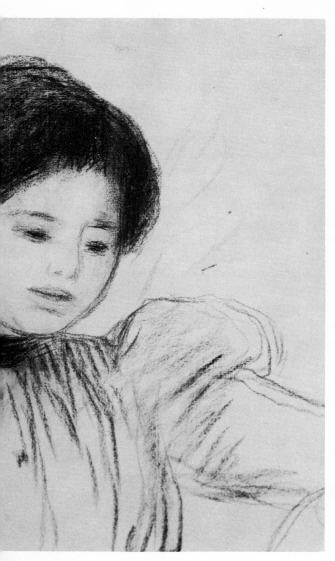

work—some estimate it at around four thousand pictures—there is no hint of darker, troubled moods. He had early years of hardship, made more disturbing by political attacks because he, as an Impressionist, did not conform to conservative standards of art; there was a period of self-doubt—often disastrous for an artist—in the eighties; there were recurrent illnesses from the age of forty-one on, with the last fifteen years of his life a torment of arthritic pain. For a few years before his death he was so crippled that he had to be carried about when he was not in his wheelchair, and his brush had to be strapped to his solidified hand. And yet, no trace of his personal suffering is anywhere to be seen in his work.

His art is always an affirmation. Instinctively he fixed on the happy aspects of the familiar things around him: the life of the streets; a beautiful day in the country; a bouquet of flowers or a profusion of fruits; people at play or making music; youth, and health. He was responsive to the delicate flower-freshness of small children, and he painted them as parents, with adoring incredulity, see their own. He had a remarkable flair for recording his time, and though his pictures never sink to the level of illustration, they still are a marvelous account of how people looked, what they wore, and what they did in their carefree moments. And the overwrought taste of the later nineteenth century has an agreeable look in Renoir's pictures, for he tempered its excesses while remaining true to its character.

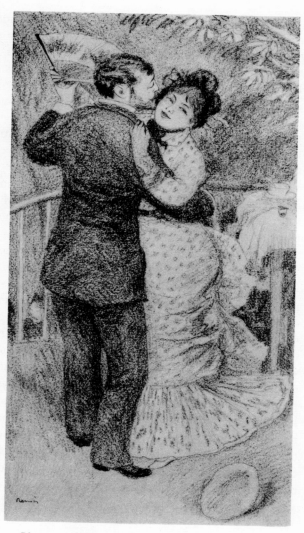

Plate 5. DANCE IN THE COUNTRY. *1883. Ink and crayon*
Paul Rosenberg Gallery, New York

Everything he touched he endowed with grace and charm. No other painter has discovered in the common actions of the human figure such vivacious gestures and attitudes, such piquant facial expressions. If Renoir is not one of the deepest of portrait painters—though he is one of the most engaging, showing us his sitters as a kindly host would see them in his parlor—he is unsurpassed as a painter of the human figure, clothed or unclothed. The female nude, above all, was his subject—he almost never painted the more angular, structurally obvious male nude—because in it he found delights of color and texture, forms which were ample, and warmth and fruitfulness and the promise of joy.

Renoir started to earn money at painting when he was thirteen. His family had come to Paris from Limoges, where he was born, and Renoir was apprenticed as a painter of porcelain. Later he did pretty ornaments on fans and window shades, borrowing motifs from the French masters of the eighteenth century—Watteau, Boucher, Fragonard—whom he was to admire all his life. This early experience, no doubt, assured the decorative grace that is always present in his work, as well as that lustrous glow of his pigment which attracts us as color-music. The realistic painting of the sixties rooted him firmly in the substantial world; and as an Impressionist he discovered how to render the passing scene as spectacle, bathing his canvases in light, and filling them with a warmth of atmosphere that is all but palpable. He

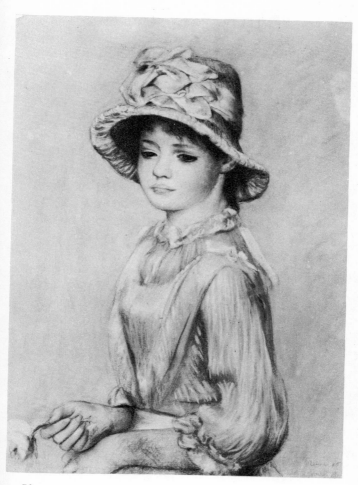

Plate 6. YOUNG GIRL WITH A ROSE. *1886. Pastel*
Courtesy Durand-Ruel, Paris

soon found that Impressionism was too limiting; subsequent works, reproduced here, show how he went beyond it. He never ceased to study the great art of the past, to which he was more closely attached than any artist of his generation—again an affirmation, this time of pleasure and nourishment found in the works of man. When asked where one learned to paint, he said, "In the museums, *parbleu!*" His final work—and here we mention also his beautiful sculpture—was in consonance with the spirit of twentieth-century painting: though he continued to image things, his lyricism was increasingly expansive and robust, inventive and daring, and Renoir came as close to an "abstract" coloristic art as his devotion to things he loved would permit.

His greatness springs from his color, of an unparalleled radiance and originality, which modeled the forms by subtle passage from nuance to nuance; a love of pigment as a magical substance; a wonderfully simplified drawing which especially in his more mature work banishes the angular, the harsh, and the rigid; and his instinct for decorative composition. Above all, there was his great love of people and the world; and the result was one of the most festive arts ever created.

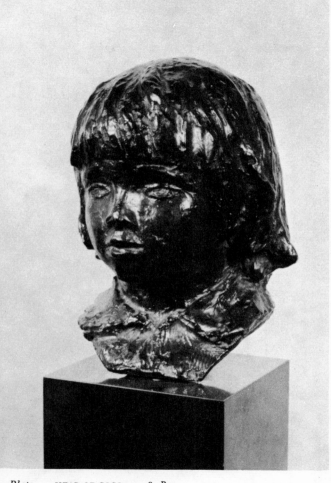

Plate 7. HEAD OF COCO. *1908. Bronze*
Knoedler Galleries, New York

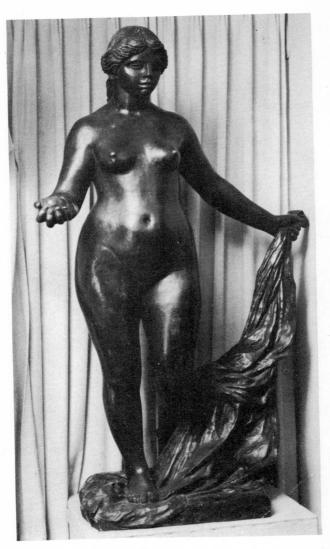

Plate 8. VENUS. *1916. Bronze*
Private Collection, São Paulo, Brazil

COLOR PLATES

PLATE 9

Painted in 1867

DIANA

National Gallery of Art, Washington
(Chester Dale Collection, Loan)
75¾ x 50½"

This early canvas is one of the few on which Renoir employed the palette knife; it was at the time when the artist admired the thick impasto pigment and powerful realism of Courbet. Though the picture was a contrived studio piece—a bid for recognition at the Salon—we now see it as one of the great realistic nude paintings of the nineteenth century. There is sensitive attention to varied textures, substances distinct in color, value, and rendering. Paint quality ranges from the smooth, unbroken sky to the enriched and dazzling flesh, then on to the more vigorously painted rocks, and finally to the broad, loose flecking of the foliage.

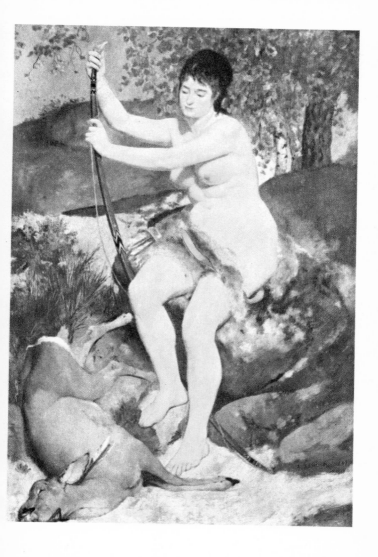

PLATE 10

Painted in 1874

THE LOGE

Courtauld Institute of Art, London

31 x 25"

This picture is a hymn to the beauty of woman. It is an image of health, an exaltation of maturity, an idealization of togetherness. With what tact Renoir has placed the man—his young brother, Edmond—in the background, covered half his face, and subdued the detail with which he is rendered! The woman is offered for full and rapturous gaze; her face and body and costume are more flowerlike than the blossoms in her hair and corsage.

Everything in the picture is developed for visual pleasure, largely through pairing. There are twin touches of color—gold, pink, black; her gloved hands; the blossom and hand at the top; the pinks of face and flower. Black, "the queen of colors," according to Renoir, is a major voice in the harmony, at once regular and free in the radiating stripes.

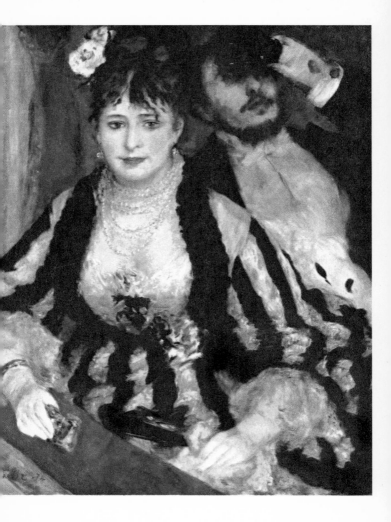

PLATE 11

Painted 1875–76

TWO LITTLE CIRCUS GIRLS

The Art Institute of Chicago

51½ x 38½"

The popular theater—the variety houses, the circus, the opera, the ballet—enchanted Renoir and his fellow-Impressionists. It offered ideal subjects for their break with tradition: lightness of spirit, moments of pure vision free from involvement with meaning or thought. This painting is a superb example. The two little girls are anonymous performers, a vision briefly seen and quickly gone. Yet somehow Renoir has preserved the portrait presence of the figures; and through the warm and cool, light and dark tones, the variation of brushwork, and the piquant touches of orange, blue, and yellow, he has created an apt and lovely image.

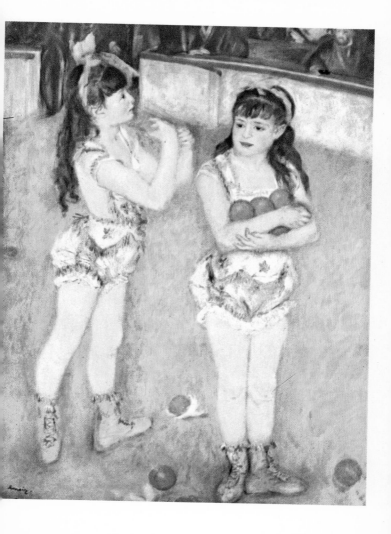

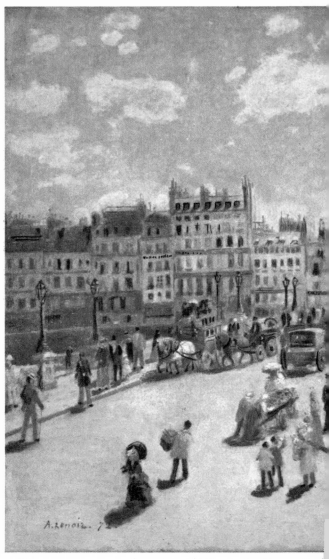

Plate 12. PONT NEUF *(commentary follows color plate section)*

PLATE 13

Painted about 1876

GIRL READING

The Louvre, Paris

18 x 15"

What a dazzling thing Renoir has made of this casual study! The light, reflected back from the book, makes the shadow of the face transparent, and Renoir there discovers a wonderful variety of fresh and subtle tints. The head glows as though lighted from within; in the verve and spontaneity of the execution, in the casual ease of the pose, the picture recalls the best in French eighteenth-century painting. The brush fairly dances a staccato beat, here laying down thick deposits and there, mere washes. The freedom and animation of the handling seems most appropriate to the relaxed mood of the model.

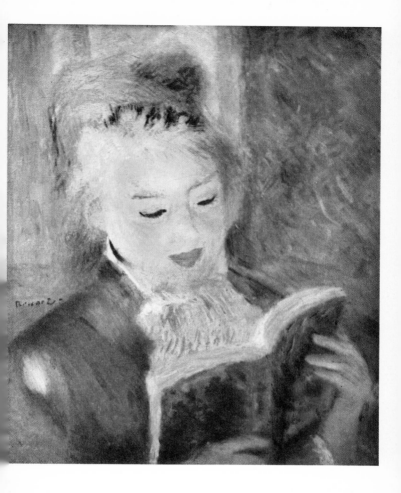

PLATE 14

Painted in 1879

THE UMBRELLAS

National Gallery, London

$70\frac{1}{2} \times 44\frac{1}{2}''$

It is a showery spring day in Paris, and all the world is outdoors. Characteristically Renoir, there is joy in the faces, forms, and activities; if anyone is dismayed by the weather he does not appear in this picture.

A silvery grey-lavender is the major color, and within its narrow range it has an extraordinary variety. Against this is played a dull gold quality, with sharper blues and greens and golden browns. And black. Always some touch of black to make the ensemble sing.

Renoir delights in the curves of the umbrellas and develops them throughout the picture: in the drawing of the girls in the foreground, in her bandbox, in the hoop, in the children's bonnets, in the trees in the background.

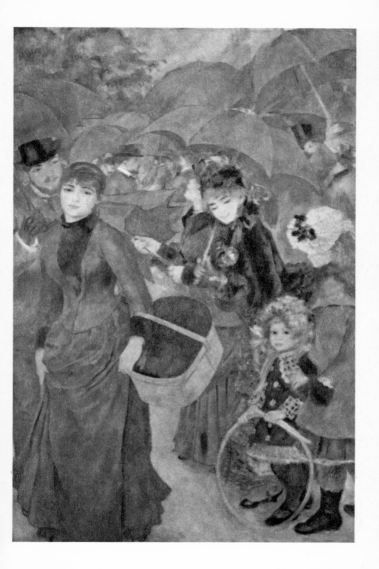

PLATE 15

Painted in 1876

MOULIN DE LA GALETTE

The Louvre, Paris

51½ x 69"

Again a canvas so rich in attractions, so full of enchant-
ing details that it becomes nothing less than an
affirmation of the goodness of living. Despite its ap-
parent crowding and turbulence, it reveals a studied
organization. The triangular foreground group is re-
lated through silhouette and color to the group at
the trees; and this group, through yellow and gold-
brown tones, becomes part of a vertical unit which
lends stability to the right side of the canvas. The other
side allows easy entrance into space over a ground
dappled blue and pink—Renoir's way of creating the
effect of sunlight and shadow without introducing
neutral dark values. With brilliant virtuosity, Renoir
has animated the figures—bold, relaxed, eager, with-
drawn, flirtatious—all of them graceful and natural.

LIFT FOLD FOR ENTIRE PAINTING →
DETAIL AT RIGHT

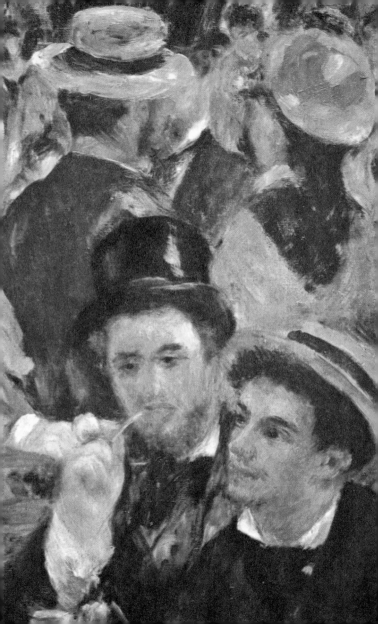

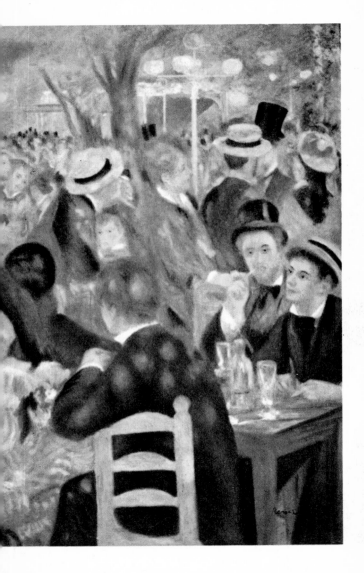

PLATE 16

Painted in 1883

DANCE AT BOUGIVAL

Museum of Fine Arts, Boston

$70\frac{7}{8} \times 38\frac{5}{8}''$

The artist is so completely identified with the spirit of the scene that every resource of his art contributes to the evocation of something wonderful and precious. Even the most casual glance reveals that the man adores the girl. We see it in the tension of his hand, as he restrains himself from squeezing her fingers too tightly, and in the carefulness with which he steers her into a turn, almost clumsy with affectionate concentration. And the girl, her body arched in the poised, yet yielding pattern of the dance, turns her head and looks away, shyly delighted with the pleasure she inspires in her companion and herself.

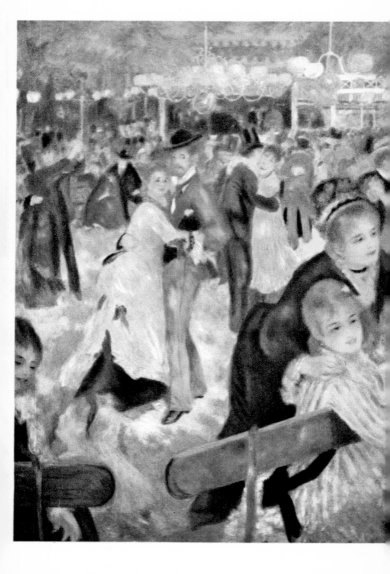

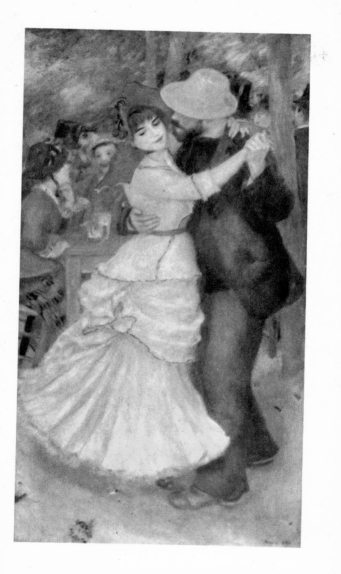

PLATE 17

Painted about 1884

GIRL WITH A STRAW HAT

Collection Mr. and Mrs. Edwin C. Vogel, New York
21½ x 18½"

Early in the eighties Renoir became dissatisfied with the Impressionist method. He embarked on what has been called his "sour period"—the *période aigre*. This picture shows something of its qualities. We note the sharp drawing, the firm modeling. The face is smooth and plump and solid as a tight-skinned apple, the curves of the hat and dress are precise. The general effect of the picture reminds us of enamel. But Renoir is still the colorist, and it is from his subtle play of warm and cool tints—and not from shadow—that we get the feeling of roundness.

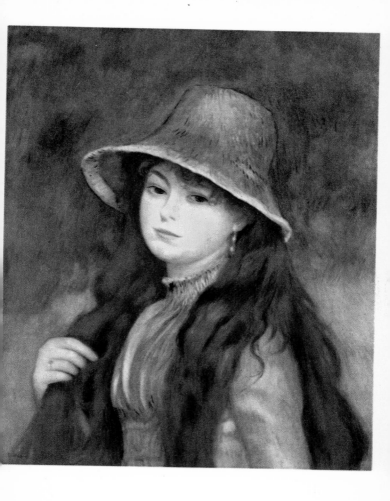

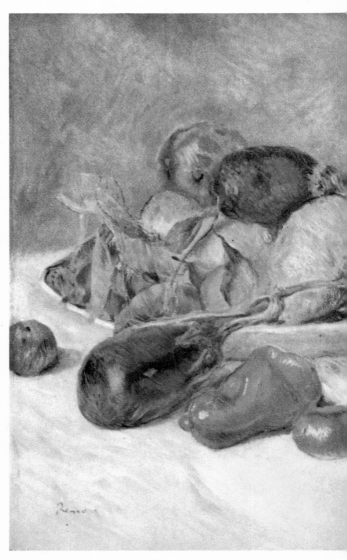

Plate 18. FRUITS OF THE MIDI *(commentary follows color plate*

PLATE 19

Painted in 1888

AFTER THE BATH

Collection Georg Reinhart, Winterthur, Switzerland

45½ x 35"

Renoir is supreme in the history of art as a painter of the female nude. In this example, he foreshadows his later sculpturesque, monumental style; there is a new warmth that springs from fullness of color, a softening of edges, enrichment of textures, and a full development of forms. But more important than the changes of style is the uniformity of his vision: his attention is not diverted to the personality of the model. There is only wonder, unself-conscious and admiring.

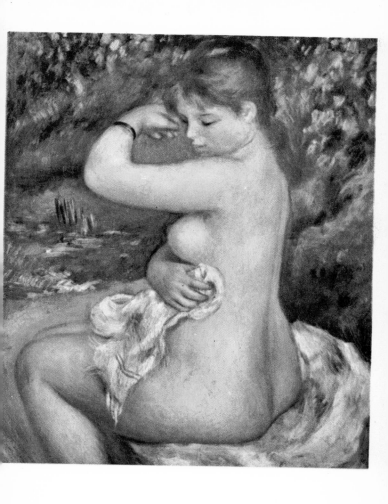

PLATE 20

Painted in 1881

LUNCHEON OF THE BOATING PARTY

The Phillips Collection, Washington, D. C.

51 x 68"

Not since the Venetian painters of the High Renaissance has the world seen such glowing opulence in painting. But whereas the Venetians generally found their inspiration in the myths and lore of ancient times, Renoir's genius transmutes the common occurrences of everyday life into Olympian grandeur. These young gods and goddesses are friends of the painter. Aline Charigot, a favorite model whom Renoir subsequently married, sits at the left toying with the dog; the other girl at the table, also a model, is Angèle, a lady of colorful reputation; Caillebotte, wealthy engineer, spare-time painter, and one of the first collectors of the Impressionists (his magnificent collection now hangs in The Louvre) sits astride the chair.

LIFT FOLD FOR ENTIRE PAINTING →

DETAIL AT RIGHT

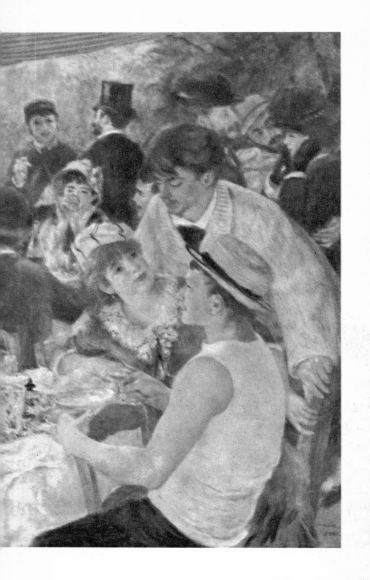

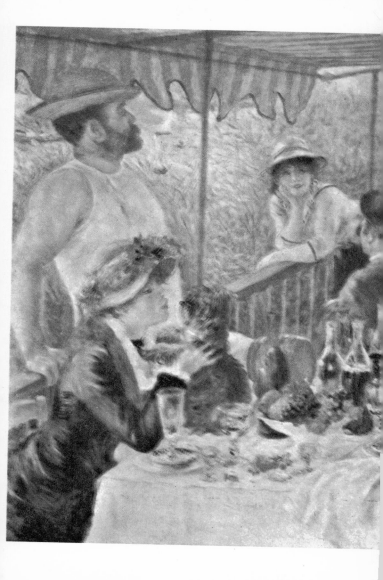

PLATE 21

Painted in 1886

MOTHER AND CHILD

Collection Mrs. Chester Beatty, London

$32 \times 25\frac{1}{2}''$

In this picture—surely one of the sweetest presentations of the mother and child theme—there are striking contrasts in technique in the figures and the landscape. The latter is an accomplished piece of Impressionist painting, its atmospheric tones bleached yet warm, its forms and textures of a caressing softness. In contrast, the mother and her child are drawn with the precise contours of Renoir's "sour period," and their surfaces are painted in more flat, unbroken tones. Yet their chalky coloring—perhaps derived from Renoir's study of Italian fresco painting a few years earlier—and many shapes and lines recall similar though diffused effects in the landscape; and one realizes how cunningly Renoir has brought into harmony the two contrasted manners of painting.

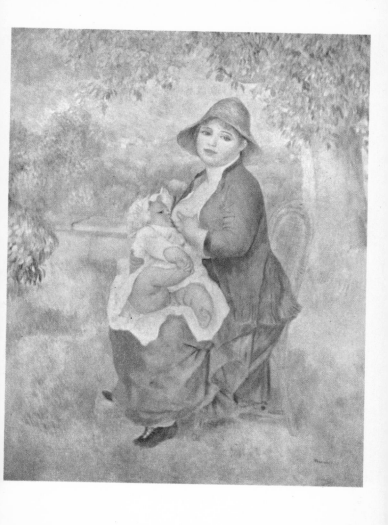

Painted about 1890

GIRL WIPING HER FEET

Paul Rosenberg Gallery, New York

$25\frac{3}{4} \times 21\frac{1}{2}''$

Renoir's "rainbow palette" is seen to perfection in this painting: his unique and rich orchestration of the whole gamut of colors. One hardly thinks of pigment substance; the effect is rather of rich, modulated light. And yet the quiet activity of the brush creates animation such as we sense when alone with the living things of nature.

Renoir's instinct for pictorial quality is seen in the way he takes an utterly natural pose, a most insignificant act, and dignifies it, gives it grandeur, and then climaxes it with the unclouded expression of the face. The disarray of the garments, hinting at the loveliness of the girl's body, is the poetic invention of a master.

AT RIGHT: DETAIL OF COVER PLATE

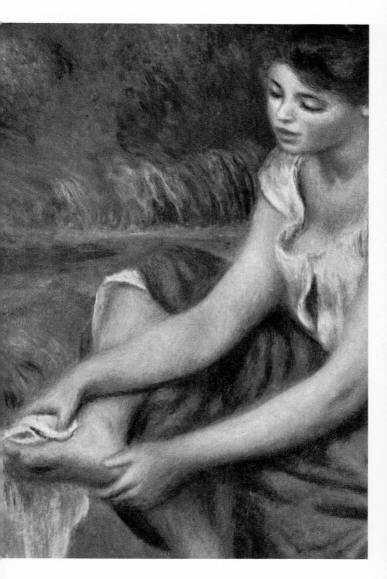

PLATE 23

Painted about 1890

IN THE MEADOW

The Metropolitan Museum of Art, New York
(Bequest of Sam A. Lewisohn)

32 x 25¾"

Here Renoir returns temporarily to Impressionism, but an Impressionism that is wholly personal and original. With a new richness of color, and a new vivacity in his brushwork, he paints thinly over light ground, creating a silken, undulant surface, like fine grass delicately swaying to a summer breeze. The effect is one of peculiar luminosity, as though, beneath the thin but complex colors, there was light and life. And although the figures are drawn with a fairly precise line—recalling his work of the eighties—we still remember pictures like this one for their color.

PLATE 24

Painted 1884–87

THE BATHERS

Collection Carroll S. Tyson, Philadelphia

45½ x 66"

This masterpiece of Renoir's "sour period" represents an amazing summation of everything he had done and learned. Here are the color and luminosity of a great Impressionist; drawing which results from his admiration of Ingres and Raphael; the benefits of his researches into the clarity and simplicity of fresco painting; the playful grace of his adored eighteenth-century French predecessors; and above all, that sweet ingenuousness which can exalt a bit of fun into something almost noble.

The intricate play of line and shape is daringly counter-pointed against the uncomplicated, cameo-smooth appearance of the figures themselves. Renoir here uses flat, unshadowed lighting, which ordinarily subdues modeling; and yet, through delicate tints, he produces a ripe fullness in the bodies.

LIFT FOLD FOR ENTIRE PAINTING →

DETAIL AT RIGHT

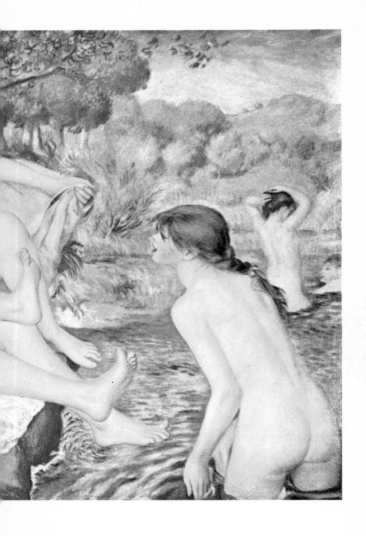

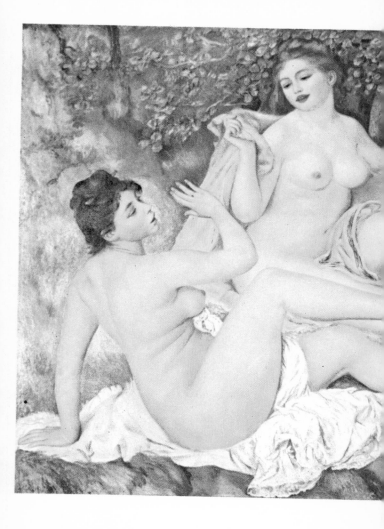

PLATE 25

Painted in 1893

TWO GIRLS AT THE PIANO

The Louvre, Paris

$27\frac{1}{4} \times 23\frac{1}{4}''$

In this picture we have a detailed and happy account of the surroundings of French family life at the end of the nineteenth century, and yet it does not break down into a clutter of things asking for attention. Its documentary character does not conflict with its qualities as art. The harsh, the rigid, and the angular are absent or suppressed; the gentle golden light which dilutes the colors brings them into the same family; and the ample forms which surround the girls seem to cushion and protect them. Yet Renoir here has given a surprising animation to a canvas which shows so little action. The soft glow of light—its source and direction are not specific—and the rosy warmth help us to participate in this moment of relaxation and companionship.

ENTIRE PAINTING AT RIGHT
LIFT FOLD FOR DETAIL →

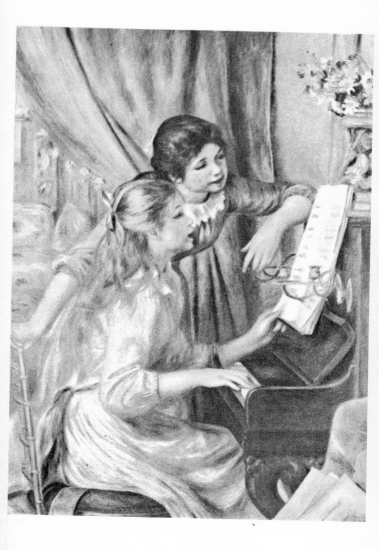

Painted in 1898

A N E M O N E S

Paul Rosenberg Gallery, New York

23 x 19½"

There are many interesting technical hints in this canvas of Renoir's method. The entire background of the picture is washed in with pigment as thin as water color. Inasmuch as the dark vase stabilizes the picture, the table top is almost entirely suppressed, lest its bulk overpower the composition: only a slight lightening of value indicates it. Yet, for the sake of controlled enrichment, the brush strokes here run in a contrasting horizontal direction. The play of stems and the ragged yellowish clusters help create that irregularity which Renoir loved.

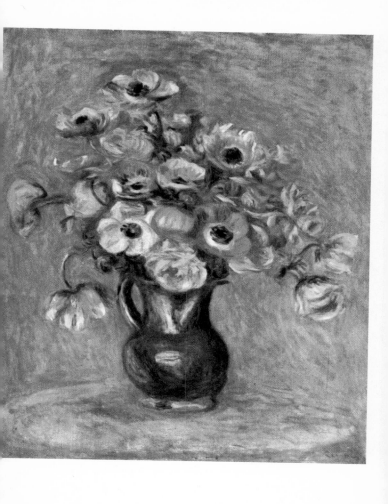

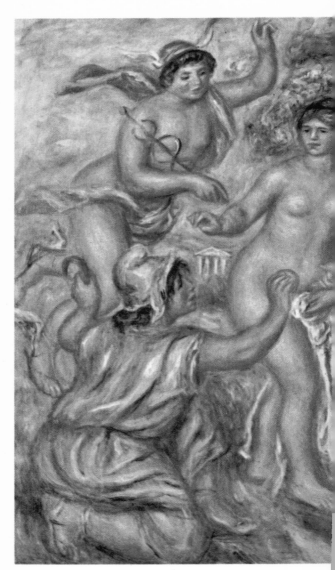

Plate 27. THE JUDGMENT OF PARIS

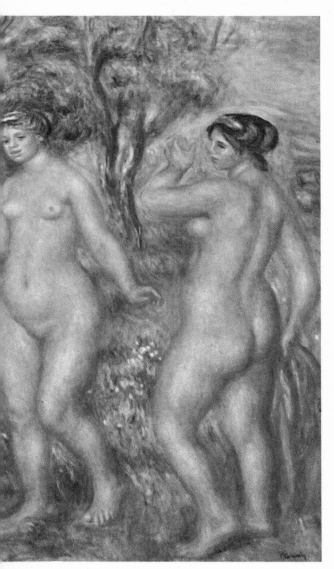

(commentary follows color plate section)

PLATE 28

Painted about 1907

GABRIELLE IN AN OPEN BLOUSE

Collection Durand-Ruel, Paris

$25\frac{3}{4} \times 21''$

In this painting of his favorite model Renoir has caught the sweetness and artlessness of maidenhood. The lively brushing of pearly greys and satiny whites gives the blouse the effect of a translucent cocoon, from which emerges the beautiful pink torso. The climax of color is in the face, broadly modeled and set off by the simple mass of hair, the dark flow of which is contrasted with the dainty blossom. Gabrielle, who also served as family nurse, clearly met Renoir's usual basic condition for employment in his household: that she have a skin that "takes the light."

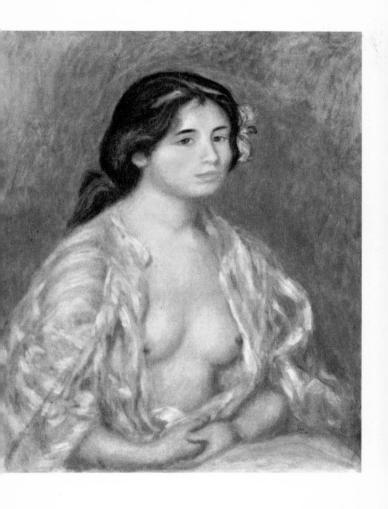

PONT NEUF *Painted in 1872*
Collection Marshall Field, New York. 29¼ x 36½"

In this masterpiece of the painting of light we have
the happiest qualities of a bright summer day in Paris.
How wonderfully Renoir has caught the vibrant many-
sidedness of the city! In a most extraordinary way we
are made to sense the large and simple compositional
structure of the canvas, while at the same time we see
the multitude of little details and contrasts of color
and shape. The world is made of spots: buildings,
windows, chimneys, flags, vehicles, statues, people; it
is made of sky and clouds, light and air, of stone and
water and foliage.

Renoir daringly makes the ground much lighter than
the cloud-flecked sky; and the contrast of the houses—
a band of luminous shadow in a back-lighted land-
scape—heightens the effect of midday glare. He cre-
ates heat through coolness; the chaos of a busy street
through order; and under his brush the grimy com-
monplaces of the city sparkle like jewels.

FRUITS OF THE MIDI *Painted in 1881*
The Art Institute of Chicago. 20 x 27"

This still life is at once like and unlike what we expect
of Renoir; it is full of surprises. A certain rugged-
ness of brushing, volume, and drawing suggests
Cézanne's influence; it may even have been painted

while Renoir was visiting his friend at L'Estaque. But the profusion—there are no less than twenty-four fruits of different varieties—is Renoir's and not Cézanne's. His, too, are the interest in textures, the abundance of color, the preoccupation with the look and feel of things. The sustained interest in the variety of highlights is Renoir's, and so is the exploitation of the decorative possibilities in the subject.

COMMENTARY FOR COLOR PLATE 27

THE JUDGMENT OF PARIS *Painted about 1914*
Collection Henry P. McIlhenny, Philadelphia. 38 x 46"

Renoir pictures this famous myth at the moment when Paris awards the golden apple to Venus. Mercury, at the left, signals the end of the contest.

The painting has a curious, but disarming, naïveté. Paris, wearing a shepherd's robe and Phrygian bonnet, is Gabrielle, as is the goddess at the right. The landscape is in the Impressionist manner, although it represents a classical scene; the faces have nothing of the traditional idealized classic type. Renoir is untroubled by these contradictions of subject and style. Indeed, one of the striking things about the picture is the degree of success with which he resolves them into an organic unity. He has not fallen into the academic trap of pretending he was more Greek than the Greeks; it is not the outward appearance of the classical tradition—worn out by centuries of misuse—which has motivated him, but its essential spirit. Without self-consciousness, drawing on his own ever-youthful vitality, Renoir brings new life to the humanistic tradition.

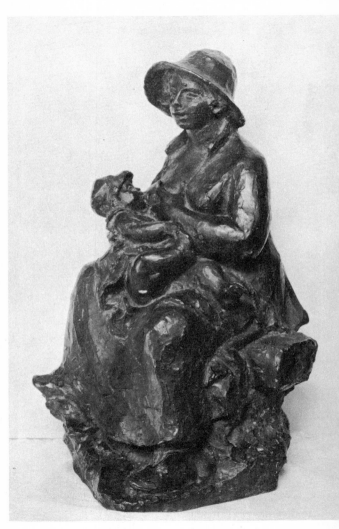

Plate 29. MOTHER AND CHILD. *1916. Bronze*
Knoedler Galleries, New York

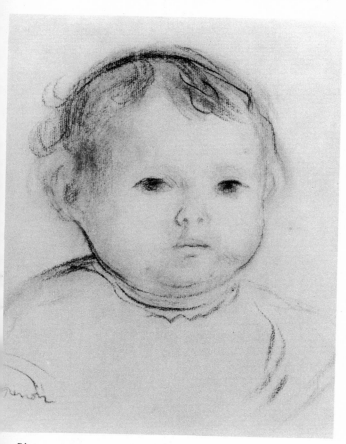

Plate 30. HEAD OF A CHILD. *About 1884. Charcoal*
Private collection, New York

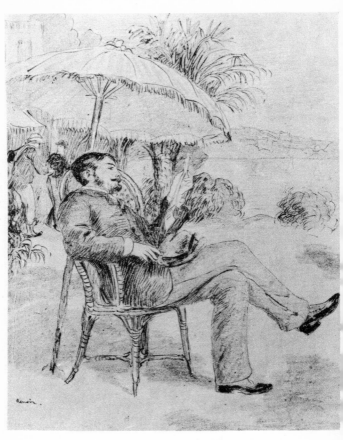

Plate 31. EDMOND RENOIR. *1883. Ink and crayon*
Courtesy Paul Rosenberg Gallery, New York

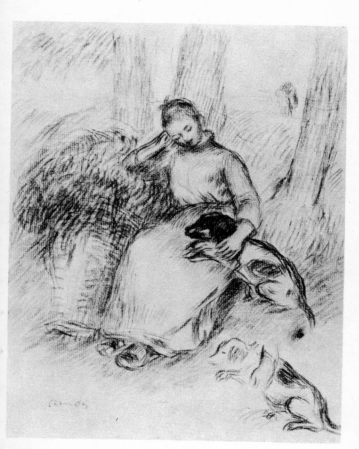

Plate 32. SIESTA. *About 1888. Sanguine*
Cleveland Museum of Art (John L. Severance Fund)

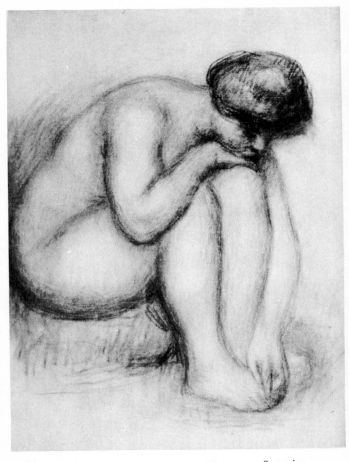

Plate 33. NUDE WOMAN DRYING HERSELF. *1912. Sanguine*
Courtesy Durand-Ruel, Paris

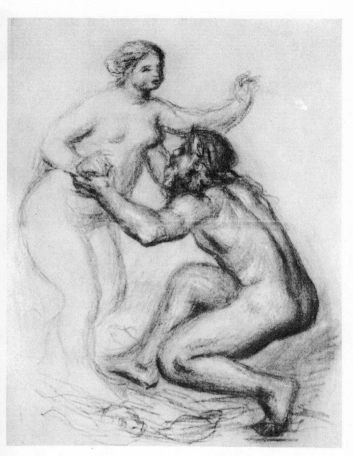

Plate 34. THE RHONE AND THE SAÔNE. *1910. Sanguine*
Courtesy Durand-Ruel, Paris

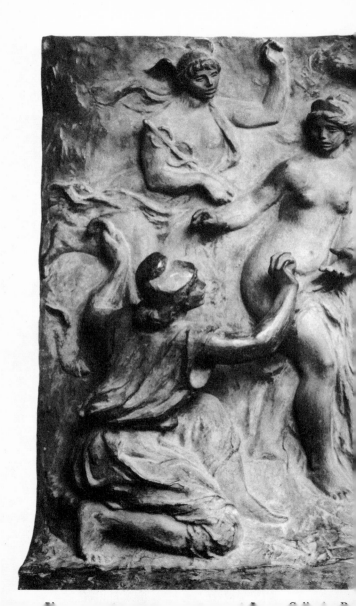

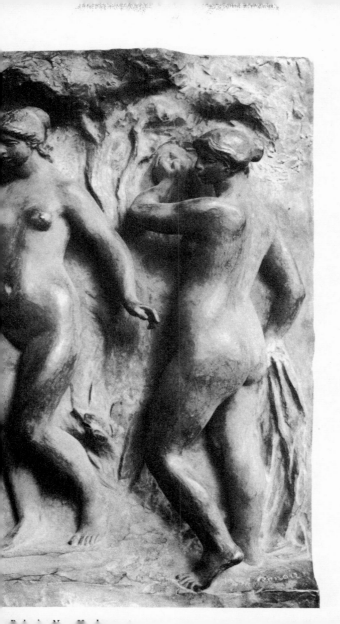

Renoir: Nudes

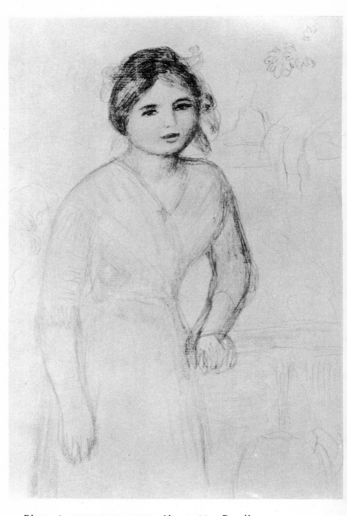

Plate 36. STUDY OF A GIRL. *About 1885. Pencil*
Rosenberg & Stiebel Galleries, New York

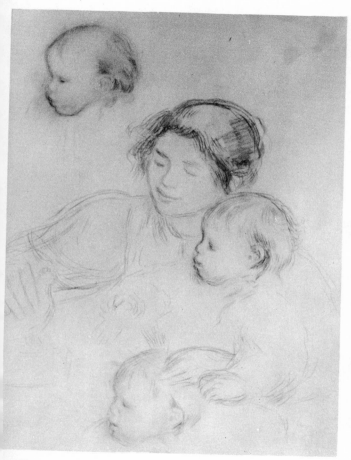

Plate 37. GABRIELLE AND JEAN. *1887. Pencil*
Knoedler Galleries, New York

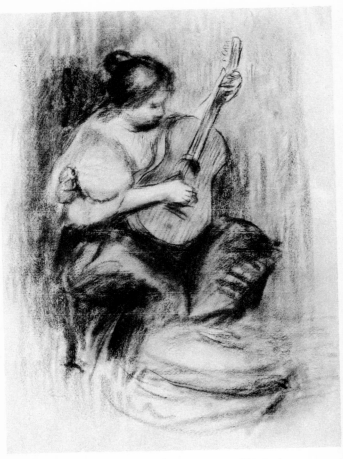

Plate 38. GIRL WITH A GUITAR. *About 1885. Charcoal*
Rosenberg & Stiebel Galleries, New York

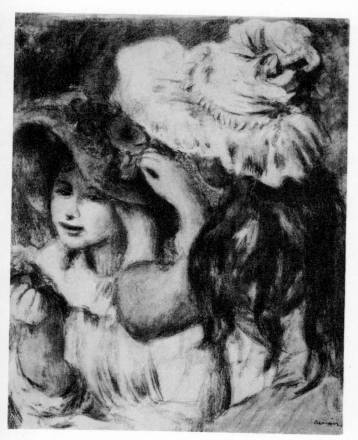

Plate 39. PINNING THE HAT. *1898. Color lithograph*
The Museum of Modern Art (Lillie P. Bliss Collection)

BIOGRAPHICAL NOTES

1841 Renoir (pronounced *ren-WAHR*) born February 25, Limoges, France. Father, a tailor, later moved family and shop to Paris.

1854–61 Leaves school to become apprentice to a porcelain painter; begins to study paintings in The Louvre.

1862–69 Enrolls at the Ecole des Beaux-Arts; meets Bazille, Monet, and Sisley.

1870 Serves in regiment of cuirassiers during Franco-Prussian War. Two pictures shown in Salon.

1874–77 Active in Impressionist group and exhibits at their first three shows.

1881–82 Travels in Algeria and Italy; enters upon so-called "sour period." Marriage to Aline Charigot.

1886–92 Withdraws from exhibits of the Impressionists. Reputation now established.

1894 First serious onslaught of arthritis which will eventually cripple him.

1895–1911 Worsening health despite travels in search of a cure. Growing fame and honors.

1912–15 Despite severe stroke, continues to paint with brushes tied to his hands. Madame Renoir dies.

1919 Taken on a wheel chair on his last visit to The Louvre. Dies at Cagnes, December 3.

"First of all be a good craftsman. This will not keep you from being a genius."

"One learns to paint at the museum. . . . One should paint for one's own time. But it is at the museum that one acquires a taste for painting that nature alone does not provide."

"Boucher's *Diana at the Bath* is the first painting that gripped me, and I have continued to love it all my life, even though I am told it was wrong and that Boucher was never more than a decorator. As if being a decorator were a defect!"

[*1882, Naples*] "I shall, I believe, have acquired the simplicity and grandeur of the ancient painters. Raphael, who did not work out-of-doors, nevertheless studied sunlight, for his frescoes are full of it. Thus, as a result of seeing the out-of-doors, I have finished by not bothering any more with the small details that extinguish instead of kindling the sun."

[*About 1883*] "I had wrung Impressionism dry, and I finally came to the conclusion that I knew neither how to paint nor how to draw. In a word, Impressionism was a blind alley, as far as I was concerned. . . . I finally realized that it was too complicated an affair, a kind of painting that made you constantly compromise with yourself. . . . If the painter works directly from nature he ultimately looks for nothing but momentary effects; he does not try to compose, and soon he gets monotonous."

"As for myself, my concern has been always to paint people like beautiful fruit."

SOME OTHER BOOKS
ABOUT RENOIR

Paul Haesaerts. *Renoir, Sculptor.* New York, Reynal and Hitchcock, 1947

Julius Meier-Graefe. *Renoir.* Paris, H. Floury, 1912

Walter Pach. *Renoir* (The Library of Great Painters). New York, Harry N. Abrams, 1950

John Rewald. *The History of Impressionism.* New York, The Museum of Modern Art, 1946
(Authoritative history of the movement)

Ambroise Vollard. *Renoir, An Intimate Record.* New York, Alfred A. Knopf, 1925
(The popular and standard biography by Renoir's dealer and intimate associate)

ACKNOWLEDGMENTS

In a book of art, it seems particularly fitting to acknowledge the work of craftsmen who contribute to its making. The color plates were made by Litho-Art, Inc., New York. The lithography is from the presses of The Meehan-Tooker Co., Inc., New York and the binding has been done by F. M. Charlton Co., New York. The paper was made by P. H. Glatfelter Co., Spring Grove, Pa. Our deepest indebtedness is to the museums, galleries, and private collectors who graciously permitted the reproduction of their paintings, drawings, and sculpture.